HEINRICH CAMPENDONK

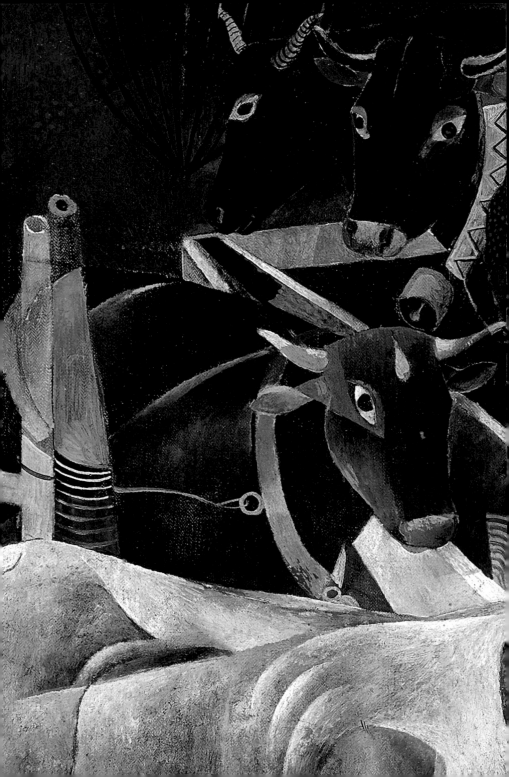

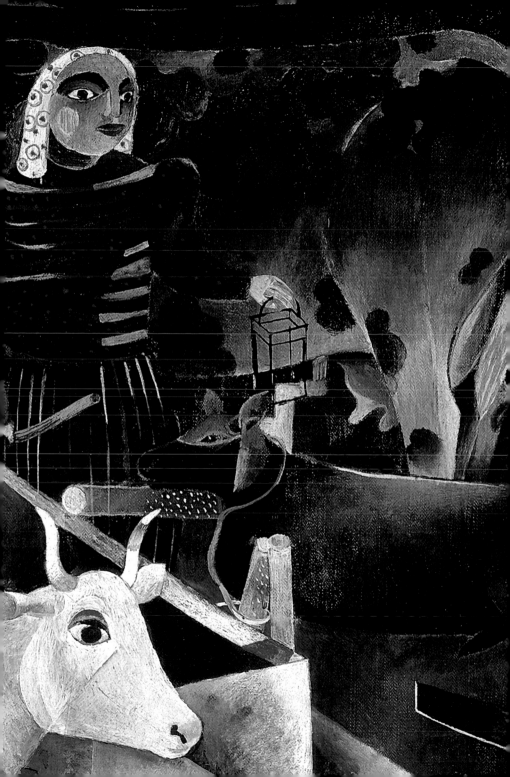

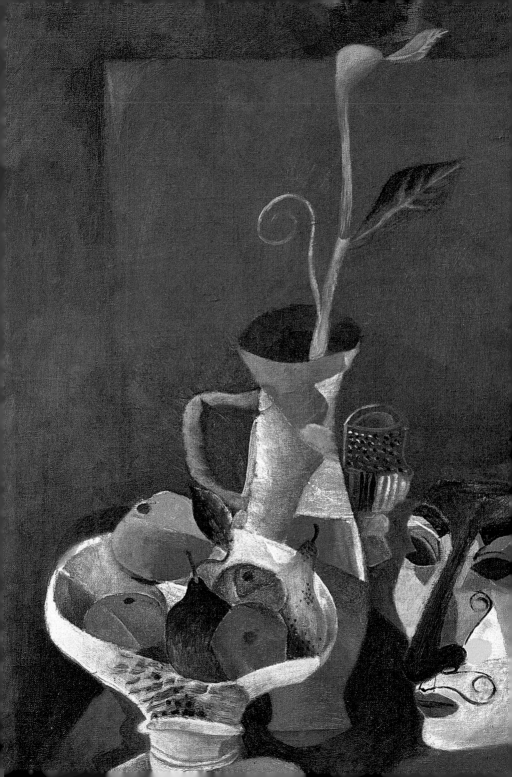

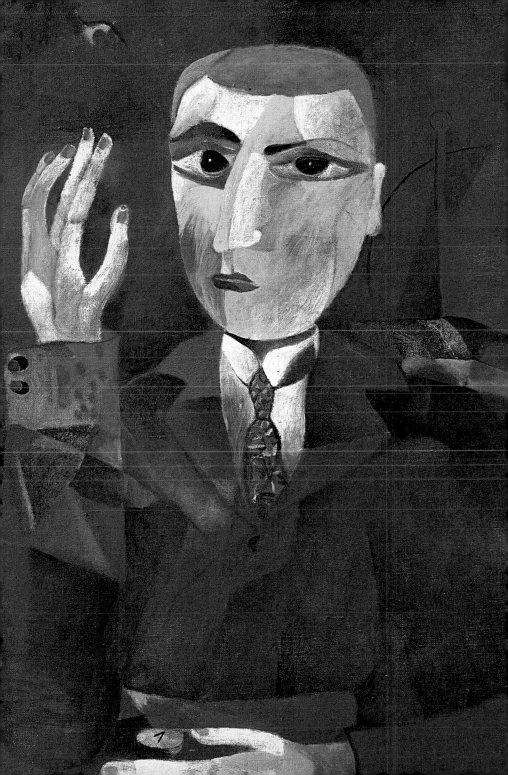

HEINRICH
CAMPENDONK

Gisela Geiger

HIRMER

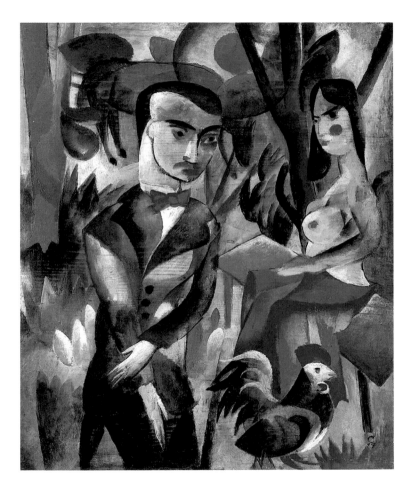

HEINRICH CAMPENDONK
Couple with Rooster, 1917
Oil on wood, private collection

CONTENTS

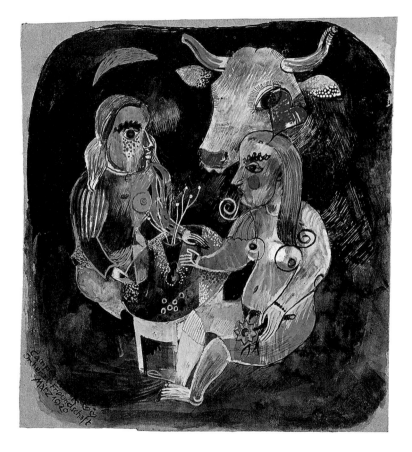

1 *Two Women at a Table*, 1920, watercolour and gouache
on brown paper, private collection

"AND I COULD SHOW PEOPLE WHO I AM."

Gisela Geiger

'This is why a Campendonk painting cannot be explained,
because the mystery is unfathomable. To analyse his work is
to hack its soul to pieces, depriving oneself of immense pleasure.'

Walter Schürmeyer 1918

An air of mystery surrounds Heinrich Campendonk. Despite his status as
an internationally renowned Expressionist artist, with paintings displayed
in the art museums of New York, Madrid, Amsterdam, St. Petersburg and
Miyagi, this man's creative achievements have been largely overlooked. In-
sights into Campendonk's life are also thin on the ground; none of his
journals have survived to the present day, his letters were never published,
and there are no known academic notes or records from his seminars.
The question that begs to be asked, then, is why is so little known about
this painter, given that he is so highly regarded? Why the disconnect in
his reception? As the youngest participant in the first exhibition of *Der
Blaue Reiter* in Munich in 1911, Heinrich Campendonk belonged to the
same circle as Wassily Kandinsky and Franz Marc. He was also among the
artists featured in August Macke's *Ausstellung Rheinischer Expressionisten*
in Bonn in 1913. Campendonk, who hailed from the Rhineland like Macke,

was living in Bavaria at this time, near Franz Marc in the village of Sindelsdorf. However, his best paintings were not produced in this early period; his most significant works came from around 1918 onward, evading categorisation with their stylistic autonomy.

The terms 'dream', 'magic' and 'mystery' are characteristic of Campendonk's paintings, which create a fairy-tale impression that gives them a fantastical, almost surreal appearance. The observer is spellbound by the artist's captivating use of colour, his masterful composition and self-assured hand. With simple motifs and distinct depictions, the paintings only reveal the full extent of their complexity to the lingering gaze, or to those who contemplate the images time and again. Everything appears to be quite clear at first glance: a landscape here, with a nude or perhaps some animals, an interior there. And yet, when looking at Campendonk's paintings, the connections between the individual elements somehow defy comprehension. The longer one dwells upon the work of art, the more mysterious it becomes. Even when everything is laid out to for us to see, we understand very little at all. The artist has not provided any further clues to aid our understanding.

Heinrich Campendonk was a reserved person, perhaps even standoffish, not exactly talkative. He was not prone to theorisation, unlike many of his contemporaries, and language was not his preferred mode of communication and expression. Only as a young man did he open up to a woman in his letters: "I always dream of painting you some day. It would have to be in summer, against the blue sky, with you in a bright red frock. I would paint your black hair in the deepest colours, with Prussian blue, […] your red blouse would soak up all the other reds, and your face would be yellowish white to dark yellow. I would intensify all the colours, and all the love I have to hold back would be set free in the picture. It would have to be a masterpiece, like the picture of Dorian Gray. Increasingly, I feel that my path will be the path of colour, and that I must forego everything else."[1] The nineteen-year-old Heinrich Campendonk from Krefeld sent this vision, dripping with interwoven colours, to his girlfriend Adda, the daughter of a military officer named Adelheid Deichmann from Kleve. In this excerpt from his letter to her, the difficulty of finding a balance between art and life instantly comes to light. He must suppress his love and his own vitality, we read, and try instead to inject his strong emotions into the colours of his paintings, pushing them to the extremes. Reading

these lines, one cannot help but be impressed by his intense perception of colours and, at the same time, sceptical about the efforts of compensation and sublimation his words imply.

THE EARLY YEARS IN KREFELD

Born into a merchant family with little tolerance for artistic ambitions, Heinrich Campendonk began training as a designer for the local textile industry in Krefeld in 1904; this was his compromise between pursuing an artistic career or getting a bread-and-butter job. The same year, the Handwerker- und Kunstgewerbeschule zu Crefeld opened. As one of the most progressive training institutes for crafts and applied arts,[2] the school paved the way for the evolution of Modernism. Rather than relying on a traditional formal repertoire, the focus was on teaching design and technique with an "independent, creative and modern concept of art". Campendonk attended the institution from 1905, and this is where his artistic development took root. He tried his hand at all manner of techniques here, bringing his ideas alive in a practical, experimental way. With his Dutch teacher Jan Thorn Prikker, Campendonk was lucky to learn from an extraordinarily talented and dedicated artist and mentor who inspired, challenged and encouraged his students with his varied methods. A solid education based on drawing scenes from nature was merely the technical foundation of the knowledge Prikker passed on to the budding artisans and artists. He wanted to share, experience and discuss so much more with his pupils, and so he took them on group trips to see modern art exhibitions as well as medieval monuments and paintings. He took his students to lectures, introduced them to art and colour theory, provided reading recommendations that ranged from the letters of Van Gogh to Indian mythology, and highlighted the social status and responsibility of the artist. He let them in on his own contentions and work, particularly symbolic mural painting, and his theosophical interests. The stylisation of natural forms was already an important subject for these budding practitioners of Jugendstil, and he gave them a basic understanding of the importance of the distribution of space and lines in design. Campendonk's classmates included Helmuth Macke and Wilhelm Wieger, as well as a few girls who had been admitted to the progressive institution.

Adelheid Deichmann also attended for a brief spell, and when she left in 1906 the two friends began an intensive correspondence. The letters provide insights into the period up to 1912, as well as showing how relentlessly determined Campendonk was to succeed in his chosen field. Fuelled by the desire for recognition that his father denied him, he worked tirelessly without becoming despondent. He threw himself into his work and the world of colour he created so wholeheartedly that he risked losing touch with his friends and classmates. In a letter to Deichmann in Kleve, he writes: 'Believe me my dear Adelheid, it is terrible to have no one to whom one can unburden oneself. [...] Indeed, I live only for painting, which is probably why people often think I am crazy. [...] colour next to colour, like an eruption, the sun in my head and a hurricane in my heart. The boldest colours appear alongside one another, terribly cold green next to blots of orange and vermilion.'[3]

Though some of this young man's self-image was undoubtedly modelled on that of his role model Van Gogh, the circumstances of his own life were difficult enough. By the end of 1907, Campendonk's father had grown weary of his artist son's fanciful ways and wanted to bring him back down to earth. Even after Campendonk left the school at his father's insistence in 1908, he remained in touch with his teacher Thorn Prikker, who was impressed by his former student's talents.

Campendonk was saved from bitter isolation and financial hardship when Helmuth Macke put him in touch with August Macke in Bavaria, through whom he then met Franz Marc and Wassily Kandinsky. Helmuth Macke went to visit his cousin August and his young wife at Lake Tegernsee, where the couple had relocated from Bonn in 1909. Campendonk was then asked to send a few pictures to Bavaria, which were evidently well received, leading to a connection with Franz Marc and the New Artists' Association of Munich. A second collection of pictures was requested in the summer of 1911. Kandinsky struck a deal with the young gallerist Alfred Flechtheim in Düsseldorf, securing money for travel expenses to Bavaria on the back of a purchase, as well as the prospect of a modest stipend in exchange for further paintings. Kandinsky also passed a commission for a Russian church on to Campendonk.

2 *Stylised*, 1907, watercolour and gouache on paper
Clemens Sels Museum, Neuss

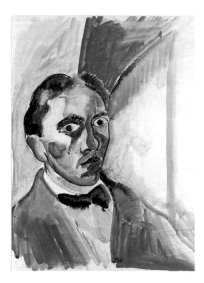

3 *Self-Portrait*, c.1909, watercolour on paper
Museum Penzberg – Sammlung Campendonk

BAVARIA & THE BLAUER REITER

In October 1911, Campendonk set off for Munich before continuing to the Bavarian Oberland, alighting at Penzberg train station. A railway line used to transport coal connected this poor mining town to the rest of the network, which primarily served tourists travelling to explore the unique pre-Alpine scenery in Kochel and Garmisch. The railway also provided a link to Munich, allowing the artists to lead an idyllic existence in the countryside without losing touch with the city of art.

Franz Marc lived in the nearby village of Sindelsdorf, while Wassily Kandinsky was based in Murnau with Gabriele Münter. At first Campendonk moved in with Helmuth Macke, but before long his friend moved on, feeling overwhelmed by the challenge of developing his own craft in the shadow of Marc, Kandinsky and August Macke. Campendonk, meanwhile, thrived. His art progressed in leaps and bounds thanks to the new environment, the work his significantly older friends were producing, their conversations, and the experience of the magnificence of the natural world around him.

Signed paintings from those years are very much a rarity, almost tantamount to a declaration: around this time, he still saw himself as an

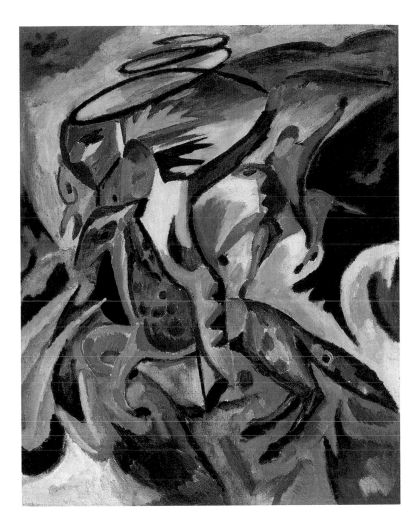

4 *Three Riders with Lasso*, c. 1911, oil on canvas, private collection

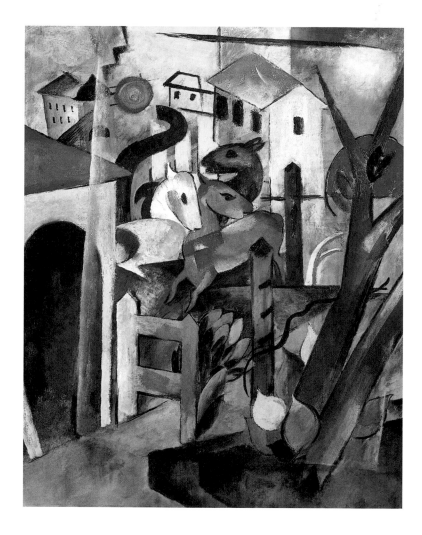

5 *Horses in the Garden; Little Horses*, 1912, oil on canvas, private collection

apprentice. Indeed, Campendonk's artistic development was marked by an active engagement with works by other artists, albeit on a thoroughly practical level; he was not one for dwelling on the theoretical constructs underpinning, for example, a painting by Kandinsky or Marc. With so many influences informing and feeding into his creative output, the task of dating his works or coming up with any kind of developmental series is a major challenge.

Influences aside, Campendonk appears to trust his own judgement, employing criteria he had picked up in Krefeld – most notably, considerations of form and colour. On the one hand, he took inspiration from Thorn Prikker, who worked intensively on composition for his mural paintings and handed this knowledge down to his students. Campendonk employed the methods he had learned from his mentor throughout his life, using compositional diagonals to arrange and open up spaces in many of his paintings. On the other hand, he had his own rigorous approach to colour perception and conscious placement of colour. In the summer of 1909 and the winter of 1910, Campendonk engaged intensively with various theories of colour, focusing on Pointillism and experimenting with the Neo-Impressionistic technique of Divisionism. In a letter to Adelheid, he discusses the endless patience he needed for the task, which also helped him hone his craft: "… [I] have seen things I never knew about before. If only Pointillism did not require so much damned work. I tell you, covering a large canvas in nothing but tiny dots without getting completely mixed up is a painstaking business, and I have often had to resist the urge to toss the whole thing into a corner."[4]

THE ARTISTIC MILIEU

The developments within the Bavarian art scene around this time were truly ground-breaking. Franz Marc was busy producing his magnificent animal paintings; meanwhile, Kandinsky, after making his breakthrough in abstract painting in 1910, was writing his book, *Concerning the Spiritual in Art*, where he arrived at a metaphysical concept of colour, one far removed from Campendonk's Neo-Impressionistic approach and its practical use of colour. Campendonk was also becoming aware of other artists, including Adolf Erbslöh and Alexander Kanoldt in Munich, but especially Gabriele

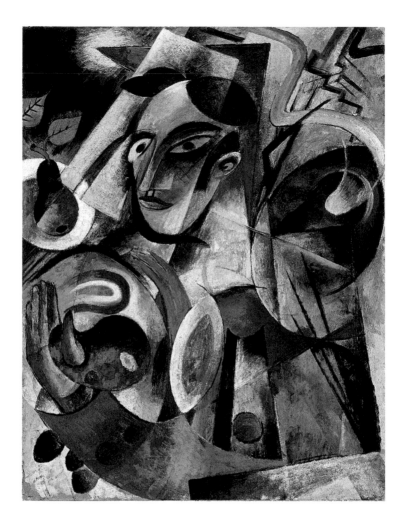

6 *Self-Portrait*, c.1912, oil on canvas, Gemeentemuseum Den Haag

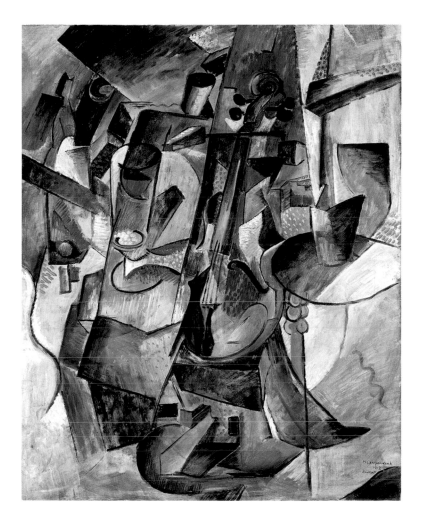

7 *Cello*, 1912, oil on canvas, Landesmuseum für Kunst und Kulturgeschichte, Münster

Münter, Marianne Werefkin, and of course, Alexej von Jawlensky. It was a prolific time for art and exhibitions, and many of the new works produced in this period are still counted among the most unusual examples from the history of art.

Marc and Kandinsky kept Campendonk up to speed with the latest offerings from Paris, and he shared their appreciation for the work. New Cubist paintings by Pablo Picasso and Georges Braque reached them from the art capital, as well as Robert Delaunay's prismatically fragmented *Eiffel Tower* series, and contributions from 'Le Douanier' Rousseau, the painter and tax collector. Campendonk's introduction to this exciting scene coincided with Kandinsky and Marc's dramatic split from the New Artists' Association of Munich (NKVM) after a heated disagreement. The two artists were busy working on the almanac *Der Blaue Reiter*, which was published in the spring of 1912, shortly after t*he First Exhibition of the Editorial Board of "Der Blaue Reiter"*, their famous counter-exhibition to the NKVM, which they had hastily thrown together in the few weeks leading up to the launch. With these contentions and essential discussions, Campendonk had finally found the vibrant environment he had longed for in Krefeld. He joined the avant-garde movement and was drawn into the group dynamic. Before the year was over, he had secured the art collector Bernhard Koehler as his patron.

FIRST DIFFERENCES BETWEEN THE ARTIST FRIENDS

In the first few months of 1912, Campendonk devoted his attention to a series of musical still lifes. The series contains a painting with a cello motif (7), presumably inspired by his brief relationship in Osnabrück with a cellist who went by the elegant stage name Cléo de Robé. The paintings, with their Cubist fragmentation and muted colours, are a nod to works by Picasso and Braque. Another likely influence is Delaunay, who featured alongside Campendonk at the *Der Blaue Reiter* exhibition. However, rather than following these new role models to the letter, he turned away from their concept of multiple perspectives and injected colour accents to break up the monochrome effect.

Encouraged by August Macke, Campendonk entered six of the pieces into the *Sonderbund Exhibition* in Cologne. He knew that the new paintings

were provocative and could already imagine being thought of as one of the most notorious artists in Cologne as a result. Even his contemporaries Marc and Kandinsky were baffled and disgruntled by these new experiments.

In early March, Campendonk stopped off to visit August Macke in Bonn after travelling to Krefeld to see his sick father. "We made big plans for the future and did our fair share of complaining about the Blauer Reiter [artists]," he writes. Campendonk was a fan of Macke's work because it did not resort to "ostentatious means". As the initial euphoria subsided, disillusionment and alienation were clearly creeping into the group. Macke, for one, had already expressed his dissatisfaction in a letter to Marc. Macke and Campendonk were more impressed by the medieval art they had seen in the museum in Bonn; they were convinced that it could very much hold its own alongside even highly modern works of art.

The artist friends were bound by a particular appreciation for the applied arts, and they were keen to exhibit crafts together. In January, under pledge of secrecy, Campendonk had already spoken of plans to establish "an academy of modern art" with a friend (Macke, perhaps?) and support from the 'Sonderbund' organizers: "Above all it should be craft-based, as a progression from painting. Hence, the students should not think about making crafts, architecture or anything else until they have truly developed their own forms and an understanding of the rules in nature. This may well be the way of the future. The kind of thing I have in mind exists nowhere [...]"5

There are many things to note here: Campendonk becomes more aware of his roots in the Rhineland as a result of his encounter with Macke, and these give him a connection with medieval art, especially with crafts and all the things that he learned with Thorn Prikker. It is also worth pointing out how close his idea comes to the plan to provide joint training for artists and craftspeople (complete with preliminary course and workshops) which later became a reality in the context of the Bauhaus, albeit without him.

The arrival of Campendonk's girlfriend in Sindelsdorf in mid-March was a major event. Adda Deichmann's decision to move to the small Bavarian village was out of the ordinary, and one cannot help but wonder what scenes preceded it back in Kleve. As a sheltered girl from a good family, travelling to meet a young man was not the done thing – especially when

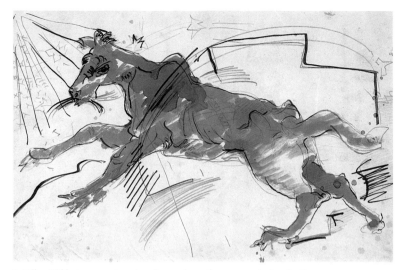

8 *Yellow Wildcat*, 1912, sepia, watercolour and pencil on paper, private collection

the relationship between them was far from clear. The two pen friends had been exchanging letters for quite some time, and Campendonk had often encouraged Adda to travel to Sindelsdorf for the sake of her art. But it was his friend who put the plan into action, working energetically to make it happen. Sadly, our insights end here, when the two of them stopped writing to one another. From a safe distance Campendonk's pen friend had transformed into a vivacious, self-assured young woman, and now he had to prove himself her equal.

THE ENCOUNTER WITH KOKOSCHKA AND
FIRST BREAKDOWN

In May, Campendonk travelled to Berlin for a fortnight to meet with Herwarth Walden and to discuss the prospect of exhibiting his artwork in Walden's Galerie Der Sturm. Walden had taken over the Blauer Reiter exhibition and sent it on a tour of Europe. The futurists' exhibition was still being shown in the gallery, and Campendonk marvelled at the vast number of paintings that had been sold.

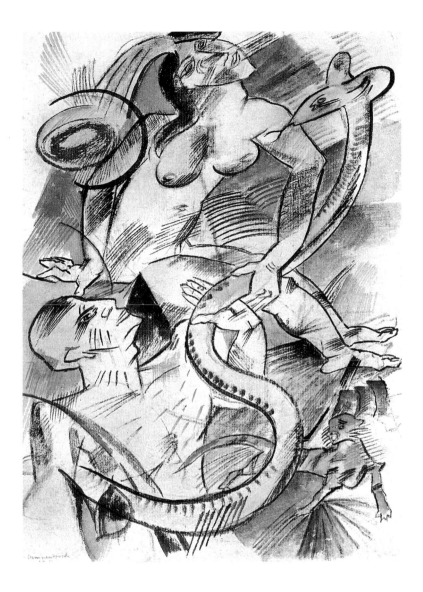

9 *Two Nudes with Cat and Snake*, 1912, brush and ink drawing
with watercolour on paper, private collection

Oskar Kokoschka's work in the Sturm gallery likely left the strongest mark on Campendonk during the trip. Walden, who was busy with preparations for his exhibition of graphic artworks by the Blauer Reiter group, added over 30 prints by Kokoschka, including *Murderer, Hope of Women*. Kokoschka's artworks, which are by no means harmonious and which contrast sharply with the style of the Blauer Reiter, may well have fascinated Campendonk. We have no statements to confirm this from the man himself, but the works produced from this point forward speak for themselves. On returning home, Campendonk received a letter of rejection from the Sonderbund. He was not alone – many other artists from the Blauer Reiter movement also learned that their submissions had been turned down. A plan was swiftly hatched to show the 'rejected' works in the Sturm gallery. For Campendonk, however, this was no consolation, and he proceeded to suffer a breakdown. The estrangement from his painter friends in Sindelsdorf and Murnau, perhaps combined with his father's illness, but most certainly exacerbated by his insecure relationship with Adda, made this experience of rejection, of being excluded from the artist community, unbearable.

In a letter from 17 July Campendonk talks about his breakdown, which is still taking its toll on him. He cuts the letter short and draws a yellow cat (8) on the reverse. This is perhaps the first in a series of around thirty ink and brush drawings that can be dated with precision. The artist's crisis, coupled with his introduction to Kokoschka's work in Berlin,[6] resulted in a new group of works which appeared suddenly and with no apparent forerunners. Candidly emotional and highly expressive, with space for negative feelings like aggression, fear and loneliness, Campendonk opened up his inner world here with lively, self-assured brush strokes.

Instead of being guided by colour, Campendonk has turned his attention to the graphic elements here. Clear, sweeping, oscillating contours, clusters of hatching that convey extreme dynamism, abstract 'unfinished' sections in black – these are all stylistic devices employed by Kokoschka. The erotic themes and palpable aggression are in no way aligned with the visual language of the Blauer Reiter artists. The figures with exaggerated hands and feet, often made to look ungainly, are powerful and expressive, with gestures evocative of German Expressionist dance. Perhaps Campendonk had seen the dance being performed in Berlin?

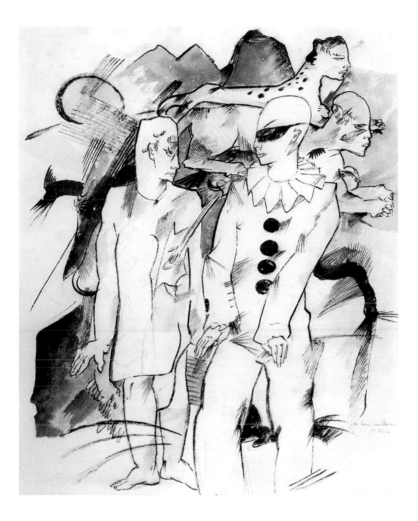

10　*Circus Artist*, 1912, brush and ink drawing with watercolour on paper
Wilhelm-Hack-Museum, Ludwigshafen

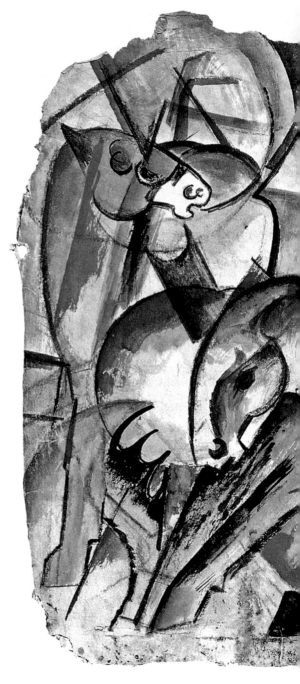

11 *Couple on the Balcony*
c. 1913, brush and ink
drawing with watercolour
on paper, Museum Penzberg
– Sammlung Campendonk

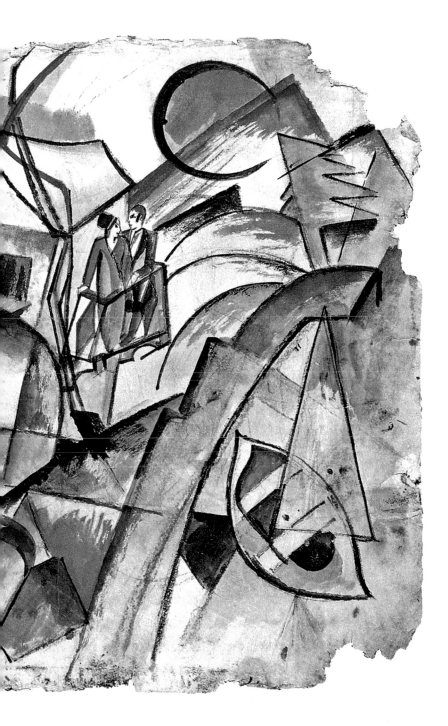

12 *Witches*, 1912, brush and ink drawing with watercolour on paper
Franz Marc Museum, Kochel am See

PERCEPTION AND RECOGNITION

Campendonk's ink and brush drawings signal an emotional and qualitative turning point from a particular time in his life. There is also something noticeably therapeutic about the drawings, which allowed the artist to find his balance once again. This shift in Campendonk's outlook resulted in the decision to marry Adda, from which point on he produced some wonderful brush and ink drawings that he painted with watercolours, reconciling his new pictorial language and freedom of expression with the artistic techniques used by his peers. The motifs that had entered Campendonk's paintings in an exceptional set of existential circumstances began to take on a kind of life of their own: reappearing in other pictures, the motifs serve as a kind of reference that imply the original context of connotation

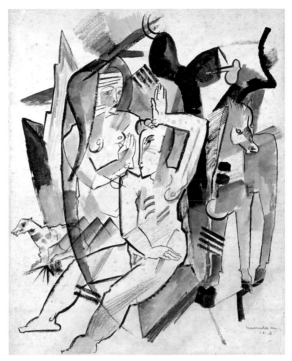

13 *Two Female Nudes with Animals*, 1913, watercolour, gouache and pastel on paper, Staatliche Museen zu Berlin

but are by no means easy to decipher. More and more, we see a move towards the symbolic in the expressive qualities of Campendonk's art.

Numerous recurring motifs function as signposts through Campendonk's pictorial world: the paraffin lamp, the fish, the cat, the bucket. The resulting metaphysical association and composition came to play a defining role in his artworks.

As one becomes aware of this element of Campendonk's paintings, the eye begins to notice series of motifs emerging from the scenes, such as a number of apparently superfluous animals that seem to have no meaningful place in the context of the pictures. Though the influence of Marc's visual world is undeniable, it must be noted that these animals have a very different role in Campendonk's art. Almost every animal depicted – be it a cat, snake, fish, rooster, horse, goat, turtle, deer or bat – is accompanied by

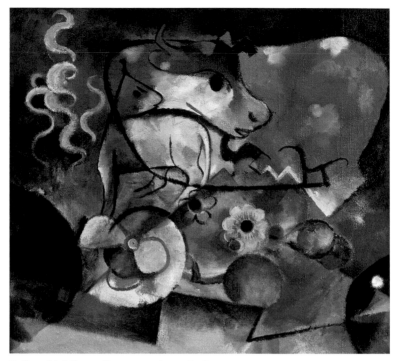

14 *Cow with Calf*, 1917, oil on canvas, private collection

at least one human being. These images are not simply an expression of an idyllic natural harmony between human beings and their fellow creatures. Rather, the animals in the paintings play a pivotal role as companions for the human figures with significant attributes, similar to what we see in medieval paintings. This is an artistic, artificial, stylised relationship that emerges from an emblematic use of expression.

Of all the animals in Campendonk's paintings, the cow is featured most frequently. But rather than trying to evoke the pastures of the Lower Rhine or Upper Bavaria, the intention is for the onlooker to reflect on the metaphorical meaning contained in the image. "The coat of arms of Saint Luke [patron saint of painters] bears an ox. Consequently, one must be as patient as an ox [...]".[7] The inclusion of cattle is therefore a reference to the painterly theme, one that simultaneously sneaks the motif of patience into the artwork.

Campendonk's personal experiences of suffering, as well as his studies for the Russian commission that came to him through Kandinsky, were the inspiration for the crucifixion motif that he used often, particularly in and around 1912. Rather than an interest in Christian iconography per se, it can be assumed that he was drawn to images like this because he knew that producing a secular version could help him make some highly idiosyncratic statements. The nude beneath the cross and the harlequin as a companion are pictorial inventions unique to Campendonk.

THE TRANSITIONAL PHASE

The oil paintings from the Sindelsdorf period are less autonomous than the brush and ink drawings. Campendonk was engaging with the stylistic devices of Expressionism during this time, predominantly those used by Marc, Macke, and above all Delaunay, who had a strong influence on

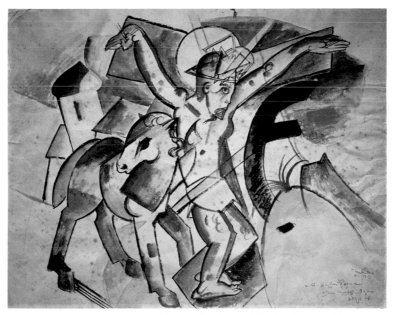

15 *Crucifixion*, 1912, brush and ink drawing with watercolour on paper
Weißenhorner Heimatmuseum

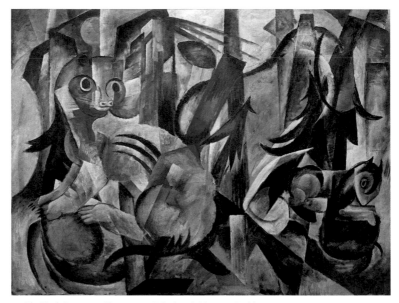

16 *The Sixth Day*, 1914, oil on canvas, Lehmbruck Museum, Duisburg

the latter two. There is less of an expressive dimension to these artworks than with the works on paper; Campendonk only really began to make his own artistic statement from this point forward. Campendonk practised the prismatic decomposition of shapes and colours, continuing to attach importance to both the distinguishable figuration and the actual painterly technique and its modulation of colours. He was constantly experimenting with different ideas, taking particular inspiration from Delaunay's use of white to create transparency, illuminate the picture and enhance its colourfulness.

The outbreak of World War I brought the artists' group effort to an abrupt halt. Marc and Macke were quickly conscripted, while Kandinsky, Jawlensky and many others were branded 'enemy aliens' and forced to leave Germany. For Campendonk, war was not synonymous with 'cleansing' and 'cultural renewal', it was a threat. He took a polar-opposite stance to Marc, a view that was only reinforced by August Macke's death in the autumn of 1914. Adda brought a son into the world in February 1915, and so when Campendonk was called up for military service in the spring of the same year, their blissful family idyll was torn apart. Charming postcards

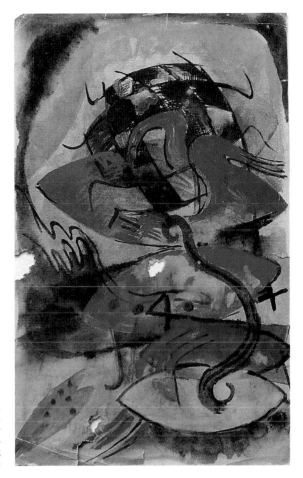

17 *Abstract Compo-*
sition I, c. 1915
Gouache on paper
Museum Penzberg –
Sammlung
Campendonk

from this period (pp. 68, 73) provide rare insights into life within the Campendonk family around this time.

On finishing his basic training in the Augsburg barracks, Campendonk had a second breakdown. He was deemed unfit for service and discharged. Although he was ultimately fortunate not to be sent to the battlefields, this was seen on the other hand as a failure.

In 1916 the young family moved to Seeshaupt, into the same neighbour-hood as the reserved animal painter Jean Bloé Niestlé. Campendonk was now artistically isolated. For his watercolours, he visited the subject of

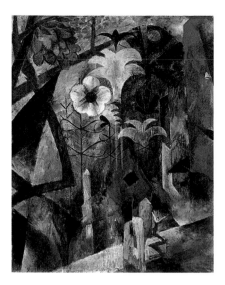

18 *Floral Painting*, c.1916, oil on canvas
Private collection

Gustave Flaubert's *Legend of Saint Julian the Hospitaller*, which Thorn Prikker had already interpreted in his very large-format designs on cardboard in 1904, as had Campendonk himself in 1907. He also designed embroidery patterns, marking a return to his Krefeld roots, and he began experimenting in a range of ways. Rare for Campendonk, two small abstract compositions also survived (17).

Very few painterly works by Campendonk are listed in the catalogue of works from this time. There are, however, at least fifteen woodcuts, almost all of which were displayed in the Sturm gallery. A number of prints, some on traditional Japanese paper, were sold and provided a basic income for the family. Campendonk continued to exhibit keenly, often with artworks from the vast collection amassed by the Berlin-based industrialist and art collector Bernhard Koehler. His correspondence with Herwarth Walden provides an insight into his prolific activity around this time: "I am very much looking forward to new projects already; this is all just the beginning."[8]

Campendonk's portrait photo (40) appeared as an artist postcard in the Sturm gallery. He also submitted a painting (19) entitled *Bavarian Landscape with Horse and Cart* for reproduction – presumably the artwork that only came back into the public domain in 2010. This piece, with

19 *Bavarian Landscape
with Horse and Cart*
c. 1916, oil on canvas
Private collection

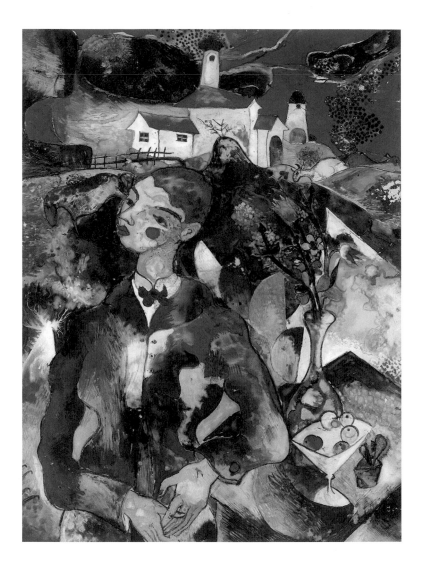

20 *Self-Portrait in Upper Bavaria*, 1917, reverse painting on glass
Clemens Sels Museum, Neuss

its unconventional elongated format, shows the extent of Campendonk's varied experiments and the new influences he was assimilating. It is undoubtedly inspired by Chagall's 1912 painting *The Cattle Dealer*, which features the quirky motif of a cart with a driver and a goat in the back. Campendonk produced several variations on this theme – a watercolour version, followed by a woodcut between the end of 1916 and the beginning of 1917. His versions depict a single-axis cart, an unstable, precarious vehicle that contrasts with the wide, horse-drawn carriage featured in Chagall's painting. After marrying Adda, Campendonk often depicted himself as an elegant man with a top hat in his paintings. Here, for instance, the sophisticated passenger and the goat sit next to one another in the meagre, rickety little cart. A graphic variation on this theme is even expressly referred to as *The Cart of Fortune*. The special relationship with Chagall's work is obvious. The Sturm gallery acted as an intermediary here, partly through reproductions and exhibitions of the paintings, and partly because Marc Chagall left his works with Walden when he travelled to Russia in June 1914. Furthermore, Campendonk frequently ordered art books from the library, including books on Campendonk and Brueghel, which he returned only grudgingly.

From 1916 he turned his focus back to reverse painting on glass – a discipline he had been familiar with since 1911. This folk technique would accompany him throughout his life, and he honed his skills with superlative sophistication.[9] He explored the possibilities and effects of various techniques by using the same motifs in different ways. As a result, he felt more certain about where his path ought to lead. From 1917 he started monogramming his works more frequently, confirming their status as originals. Despite the growing interest in these pieces, Campendonk found it difficult to part with his paintings and sell them on.

RAPTURE AND REDUCTION

When Campendonk finished his watercolour painting *Penzberg Rider* (21) in 1918, he considered it to be his most accomplished work to date. In it he achieved the magical luminescence and the subtle interplay of colours that was to become his hallmark of quality. Proud of his achievement, he signed the painting with his full name. With the Great War over, he returned

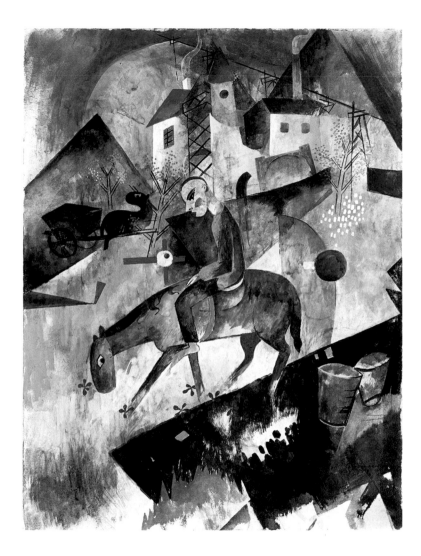

21 *Penzberg Rider*, 1918, watercolour on paper
Museum Abteiberg, Mönchengladbach

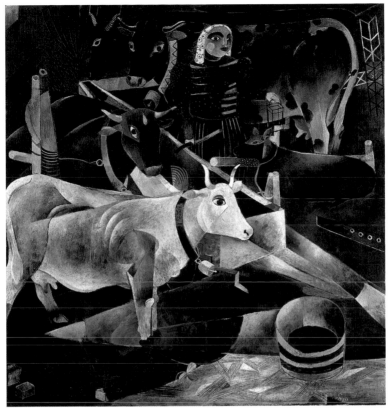

22 *The Cow Shed I*, 1920, oil on canvas, Kunstsammlungen Chemnitz

once more to the blue rider motif – albeit with a twist: rather than the victorious St George in Kandinsky's interpretation, the rider is a hunched fool without any reins. Forming the backdrop is Penzberg, an impoverished mining town in desperate need of social change, on the verge of revolution. The ground is symbolically torn open in the picture, with the fire fuelled by the coals flaming out of it. The motif of the unsteady cart also recurs here. Stylistically, Campendonk has struck a balance between figuration and abstract elements, integrating these into a compositional arrangement with great depth gradation in the picture's surface.

The artist made a similar breakthrough in oil painting in 1920 with *The Cow Shed I* (22). Here, the vibrant colours of the Blaue Reiter movement

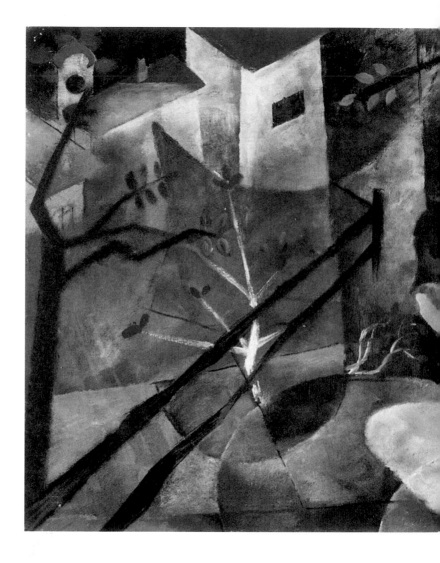

23 *Cowherd with Cow*, c.1920, oil on canvas
Städtische Galerie im Lenbachhaus und Kunstbau München, Munich

are subdued, making way for a subtle placement of colour in which the contrast between light and dark, and the strong flashes of individual colours are used in a rigorous, spatialising diagonal composition. Extreme stylisation and formal reduction are the preferred mode here.

The seated female nude in a rural landscape is a motif that appears in numerous variations. These pictures are provocatively static; in Germany they were known as *Zustandsbilder* (statal images) because the surreal element of the apparent idyll outweighs the bucolic mood. All the underlying emotionality is symbolic, present in the mystically enhanced colours. Campendonk's marriage was not unaffected by this. – An article by his friend Walter Schürmeyer discusses this ecstatic period of creativity in Campendonk's career. The artist approved the article and allowed it to be printed. Describing the pictures from this period, Schürmeyer writes: "Hence he jumbles up forms from real life at will, since their only worth to him is as part of the sensation that has stirred his inner being. The objects are transformed, amplified and distorted inside his feverishly active brain, making them subordinate to the spiritual whole and removing the illusion

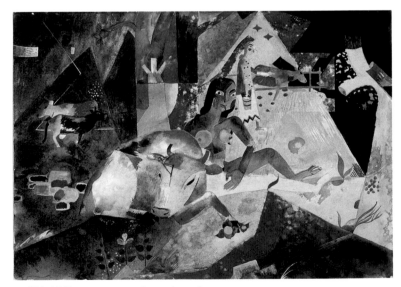

24 *Girl with Cows*, c. 1919, watercolour and gouache on paper
Private collection

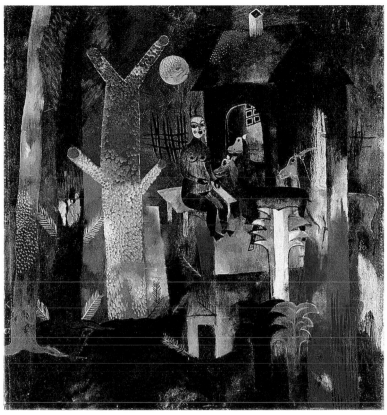

25 *Girl with Goats*, 1920, oil on canvas, Gemeentemuseum Den Haag

of physicality."[10] This description conjures up turbulent, moving images that contort and distort. In fact, they are the opposite. In combination with Campendonk's subtle yet highly expressive use of colour, the complex, nuanced distribution of light, and the ground of the painting – which was becoming increasingly important in its own right – the images were increasingly becoming magical moments, unusually evocative mises-en-scene.

Meanwhile, the real Heinrich Campendonk was leading an idyllic life with his wife and two children by Lake Starnberg in southern Bavaria. The area was relatively sheltered from the war; the living conditions were poor but better than in the cities. The family had taken up residence in a spacious

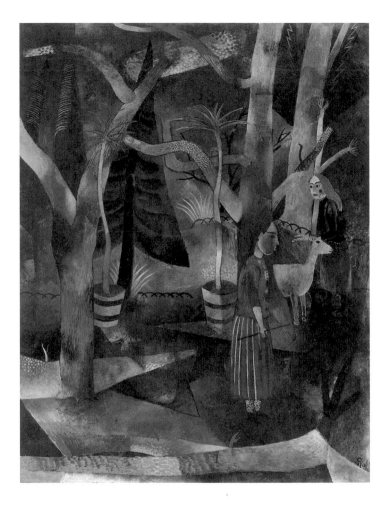

26 *The Garden*, 1920, oil on canvas, Staatsgalerie Stuttgart

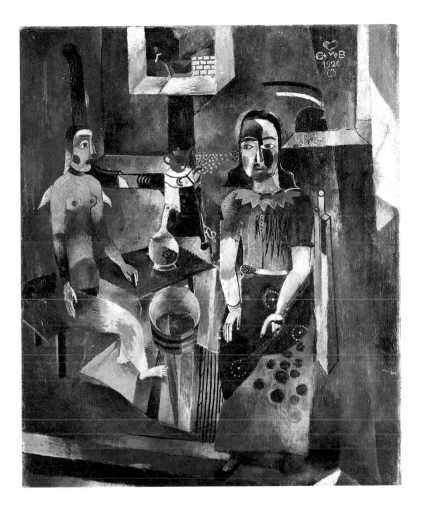

27 *Interior with Red Teapot*, 1920, oil on canvas, Gemeentemuseum Den Haag

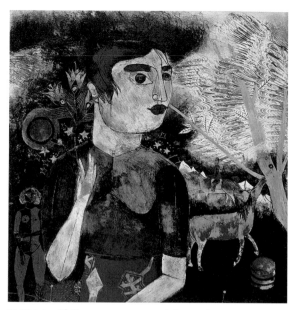

28 *Woman with Flower*, c. 1925, reverse painting on glass
Clemens Sels Museum, Neuss

farmhouse, with a separate studio for Campendonk to focus on his art. Even so, the disaster of war and the personal threat were constantly hanging over the artist, who was repeatedly called up for military physicals. In 1919, he and Klee became involved in the Revolutionary Art Workers Council and began campaigning for better conditions for artists in the new social order. Motifs from the nearby revolutionary working-class town of Penzberg became increasingly common in Campendonk's work – and he was disappointed that the Bavarian Soviet Republic had folded. This stance was based more on the anti-bourgeois, social reformist example provided by Thorn Prikker than a case of the artist having his own clear view of politics.

Despite the distinctly conventional overtone to his letters, we learn that Campendonk was not 'bourgeois'; this much is confirmed by Paul van Ostaijen, who was probably his closest friend. Following one of his lengthy visits to Seeshaupt, the Berlin-exiled poet and writer issued the following verdict: 'Camp. remains a friend whom I hold in very high regard.

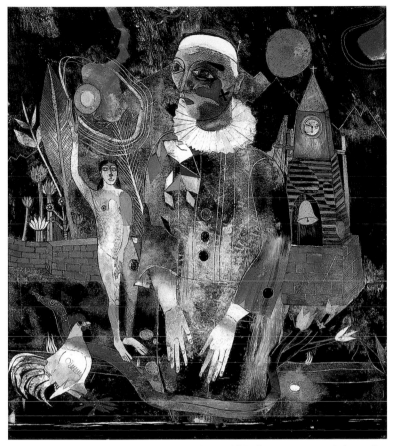

29 *Pierrot with Snake*, c.1923, reverse painting on glass
Kaiser Wilhelm Museum, Krefeld

Rational, conscious artist, and in no respect bourgeois. Tremendous re-
sistance to any attempt to force him into bourgeois society.'[11]

Campendonk established a contact with Katherine Dreier, who brought
the artist to the attention of collectors in the United States and exhibited
his work in the context of the Société Anonyme. Together with Marcel
Duchamp, he was called to the board of directors in 1923. When Ostaijen,
Prikker and even Klee left Bavaria, Campendonk felt isolated and want-
ed to break away too. The money he was making from his contract with

Galerie Zingler provided for the family's needs. But as far as Campendonk was concerned, the idea of living from the sales of his paintings to collectors who made a fortune from the war was out of the question. As an artist with a social conscience, he wanted to play a role in society and earn an honourable wage; ultimately, a professorship was what he needed. Tentatively, he accepted a post at the Essen School of Applied Arts in 1921, but his successful work with his students soon began to hinder his own work. In 1922, the Düsseldorf-based collector Paul Multhaupt facilitated the artist's return to Krefeld, providing him with a house built especially for him. Campendonk had never lost touch with his contacts in the Rhineland, and he had taken part in all the important exhibitions. And now, the Kaiser Wilhelm Museum in Krefeld was hosting a solo exhibition of his work. Campendonk poured his energy into the applied arts again, producing designs for tapestries, murals and the Königliche Porzellan-Manufaktur

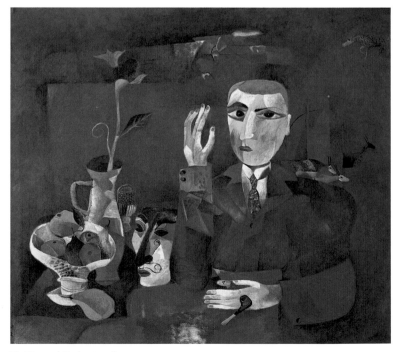

30 *Man and Mask*, 1922, oil on canvas
Kunstmuseum Bonn

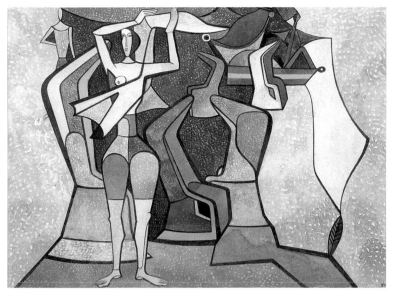

31 *Wicker Beach Chairs*, 1950, watercolour, Museum Penzberg – Sammlung Campendonk

in Berlin. His set designs also proved hugely successful. Taking another cue from Prikker, he also turned his hand to designing stained glass windows once more, using the medium to inject drama into public spaces, much like set designs in a theatre. The interplay of light, which had been a crucial element of his paintings, was now taken to the next level. In 1926, Campendonk succeeded Prikker as the chair of the Düsseldorf Akademie, an institution that brought together a select circle of Expressionist artists under modernist director Walter Kaesbach. Another artist to join the academy was Paul Klee, having left the Bauhaus school in 1930. The first solo exhibition of Campendonk's work at the New York Museum of Modern Art followed in 1931.

Campendonk was able to pick and choose from the offers of teaching posts, and he managed to bring about a symbiosis of free painting and applied arts, dividing his time between both these disciplines. He had reached the peak of his career and his ability as an artist.

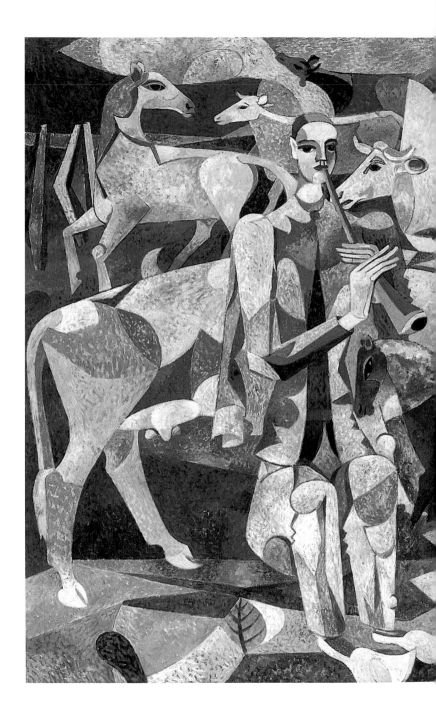

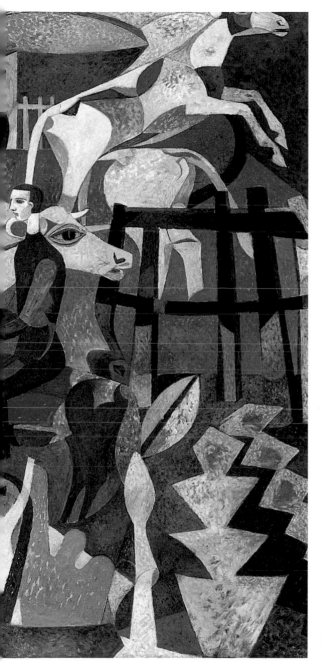

32 *The Blue Rider*
c. 1952, oil on canvas
Private collection

Things quickly went downhill in 1933, when Campendonk was ousted from his teaching post by the Nazi administration. He was informed of his forced leave of absence during the semester holidays, on a trip to the Lofoten Islands. Instead of returning to Germany, Campendonk went into exile in Antwerp with a Belgium woman named Edith van Leckwyck, who was later to become his second wife. The drawings from this period are a testament to how profoundly he was affected by the loss of his homeland. In 1935, he was appointed as the professor for monumental art at the State Academy of Fine Arts in Amsterdam. Campendonk devoted himself to his students with great dedication and success. The royal family hired him to design windows for public spaces, as well as for banks and railway stations, and he received commissions for church windows from Germany. In 1937 he produced his stained glass window, called *Instruments of the Passion*, for the Dutch pavilion at the World Exhibition in Paris. Fending off considerable competition from Picasso's *Guernica* at the Spanish Pavilion and Delaunay's murals at the French Pavilion, Campendonk's contribution won the coveted '*Grand Prix*'. At the same time, the notorious *Degenerate Art* exhibition was opening in Munich, featuring six of his paintings. The defamation and devaluation of his work hurt him profoundly, with the diametrically opposed stances towards his art in Germany and the Netherlands forming a paralysing constellation.

Though Campendonk became increasingly withdrawn in his private life, in public he was a very busy artist. The German invasion of the Netherlands spelled disaster for him. When he was called up for sentry duty, he suffered another breakdown and narrowly escaped being taken back to Germany.

There were concerted efforts to bring Campendonk back to Germany after the war, from both Düsseldorf and Krefeld. The artist initially accepted a professorship at the Düsseldorf Academy, but could not bring himself to follow through. From 1946, he produced an extensive body of late work, which with the exception of his window designs remained completely private. No one else had any chance to look at these creations. Adept at avoiding face-to-face encounters, the artist kept loosely in touch with his German friends through letters. He chose not to take part in any more exhibitions, eschewing any ambitions that might lead in this direction.

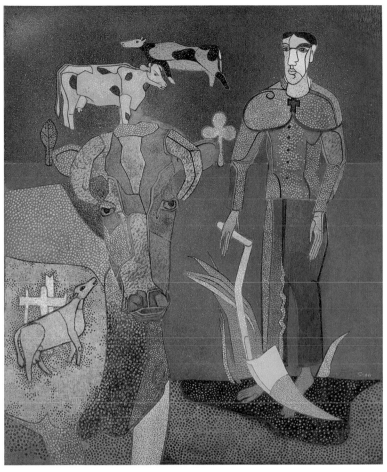

33 *Reaper with Cows*, 1946, reverse painting on glass
Museum Penzberg – Sammlung Campendonk

Numerous reverse paintings on glass were produced during this phase. Though they revisit familiar motifs from Campendonk's earlier work, the style is more pared down than before. With bright colours, glistening depths and clear lines, the glass paintings show an even greater personal reserve. Campendonk loved to enhance the interplay of light by varying opaque and transparent surfaces, some of which were backed with foil. The option of scraping out sections he had painted and add texture with

dots and hatching was also important to him. As an artist inclined to overt encryption and pointing at what lies beyond the surface, Campendonk must have been fascinated by the challenge of working with nothing but the impenetrable, transparent face of the glass. The choice of this technique alone is emblematic of Campendonk's late-career work.

As Campendonk withdrew from the renascent activity in the field of fine arts and exhibitions in post-war Germany, many of his artworks remained stowed away in warehouses. Even when the Expressionists were rediscovered after World War II had ended, this lingering effect of the process of defamation and proscription by the Nazis which had culminated in the 'Degenerate' Art exhibition was not addressed or undone. Campendonk's legacy was largely forgotten, taking with it the renown and appreciation he had once enjoyed. He became a case for specialists and connoisseurs, who continued to hold him in high regard. The fresh impetus for rediscovering Campendonk's oeuvre came only when Andrea Firmenich published his catalogue raisonné in 1989, many years after his death in 1957.[12]

GISELA GEIGER *was the curator and director of the Campendonk Collection at the Museum Penzberg, which is home to the biggest collection of artworks from Heinrich Campendonk's estate. As an author and a publisher, she has been involved in numerous publications on Campendonk.*

1 Letter to Adelheid Deichmann, 13 January 1909. The letters to Adelheid Deichmann are property of the family and were kindly provided in a transcription by Andrea Firmenich.
2 Burkhard Leismann (ed.), *Reformzwang. Zur Frühgeschichte der Moderne im Rheinland*, Ahlen/Würzburg 1999.
3 Letter to Adelheid Deichmann, 23 August 1907.
4 Letter to Adelheid Deichmann, 10 November 1909.
5 Letter to August Macke, 30 January 1912.
6 Ron Manheim, "Heinrich Campendonk und seine Begegnung mit den Werken Oskar Kokoschkas im Berliner Sturm," in: *Heinrich Campendonk. Das Kokoschka Erlebnis und die Folgen*, Bonn 2002.
7 Letter to Adelheid Deichmann, Christmas 1908.
8 Letter to Herwarth Walden, August 1916.
9 Gisela Geiger, Simone Bretz (eds.), *Heinrich Campendonk. Die Hinterglasbilder. Werkverzeichnis*, Cologne 2017.
10 Walter Schürmeyer, "Heinrich Campendonk," in: *Das Kunstblatt 2*, 1918, pp.104–117; here, p.116f.
11 Paul van Ostaijen in a letter to Fritz Stuckenberg, 4 October 1920, in: Francis Bulhof, *Eine Künstlerfreundschaft. Der Briefwechsel zwischen Fritz Stuckenberg und Paul van Ostaijen 1919–1927*, Oldenburg 1992.
12 Andrea Firmenich, *Heinrich Campendonk 1889–1957. Leben und expressionistisches Werk*, Recklinghausen 1989.

BIOGRAPHY

Heinrich Campendonk
1889–1957

1889 Heinrich Campendonk is born on 3 November in Krefeld in the Rhineland. He is the only child of the textile merchant Heinrich Gottfried Campendonk and his wife Catharina Campendonk (née Wicken). The family lives in modest circumstances; Campendonk's parents do not encourage their son's artistic talent.

1905 After leaving higher vocational school, Campendonk joins the local art and crafts school, the Handwerker- und Kunstgewerbeschule zu Crefeld, which had been established in 1904. Here, the Dutch painter Jan Thorn Prikker becomes his most important teacher and his biggest supporter. At the school, Campendonk becomes acquainted with one of August Macke's cousins, Helmuth Macke, and Adelheid (Adda) Deichmann, the daughter of a military officer from Kleve.

1908 Campendonk rents a studio on Moerser Strasse on the outskirts of Krefeld, sharing with his classmate Walter Giskes and, later, Helmuth Macke. He is forced to leave the school in April, pressured by his father. He becomes friends with painter Heinrich Nauen.

1909 Campendonk's relationship with his parents grows even more strained after they demand he gives up his studio. He attends evening classes at the Krefeld Kunstgewerbeschule.

1910 Through Helmuth Macke, Campendonk sends his paintings to August Macke in Tegernsee and subsequently makes contact with the New Artists' Association of Munich. He leaves his parents' home in March and moves to Osnabrück to assist with the painting of the cathedral murals. His financial situation deteriorates on returning to Krefeld, and he feels isolated following the departure of his friends.

1911 Campendonk meets Franz Marc through August Macke and accepts his invitation to relocate to Sindelsdorf, Upper Bavaria, in October. He makes numerous acquaintances, including Wassily Kandinsky, Paul Klee, Alexei Jawlensky, Marianne von Werefkin, Louis Moilliet, Gabriele Münter, Jean-Bloé Niestlé, and Adolf Erbslöh, as well as art dealer Alfred Flechtheim. Three of his paintings are shown in the exhibition of *Der Blaue Reiter* at Galerie Thannhauser in Munich from 18 December to 1 January 1912.

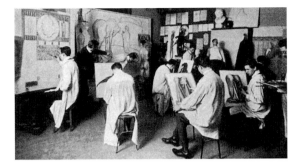

34 Inside Jan Thorn Prikker's studio, 1905

35 Students of the Kunstgewerbeschule Krefeld drawing outdoors, c. 1907

36 Heinrich Campendonk, 1907

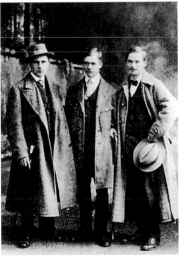

37 Heinrich Campendonk, Helmuth Macke and Wilhelm Wieger (from left to right), c. 1910

Through this same circle he becomes acquainted with Bernhard Koehler, an entrepreneur and art collector from Berlin, who remains his most important patron until into the 1920s.

1912 The exhibition of *Der Blaue Reiter* is taken on an extensive tour of Europe organised by the new Sturm gallery in Berlin. Two of Campendonk's drawings are included in the second *Schwarz-Weiß* exhibition at the Galerie Goltz in Munich. Adelheid Deichmann moves to Sindelsdorf in April. Shortly afterwards, Campendonk visits Herwarth Walden at the Sturm gallery in Berlin, where the works he sees by Oskar Kokoschka have a lasting impact on him. Back in Sindelsdorf, he learns that his paintings have been turned down by the organisers of the *Sonderbund Exhibition* in Cologne. He is deeply disappointed, and his health takes a turn for the worse.

1913 Campendonk and Adelheid Deichmann are married on 17 June. The couple move to Sindelsdorf-Urthal. Campendonk takes part in the *Rheinische Expressionisten* exhibition in Bonn in July, and in the *Erster Deutscher Herbstsalon* in Berlin in September.

1914 Marc and Niestlé leave Sindelsdorf. Franz Marc is conscripted at the beginning of World War I, as are August and Helmuth Macke, followed by Paul Klee shortly thereafter. Campendonk is against the war and afraid of being conscripted, sparking differences with his painter friends. August Macke is killed at the front in Champagne on 26 September.

1915 Following the birth of his son Herbert in February, Campendonk is called up for service in the spring. He is stationed in Augsburg, in the Third Bavarian Infantry Regiment, before being discharged for health reasons in late April. With his lease expiring in Urthal, Campendonk seeks a change of scenery and tries to leave Bavaria.

1916 Franz Marc is killed in Verdun on 4 March. Campendonk is devastated by the news. The artist and his family move to Seeshaupt on Lake Starnberg in May, marking the start of a new phase in his artistic development.

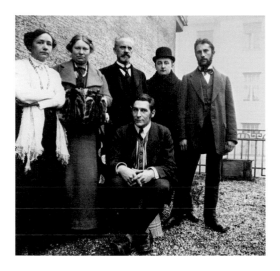

38 From left to right: Gabriele Münter, Maria Marc, Bernhard Koehler Senior, Thomas von Hartmann, Heinrich Campendonk and (seated) Franz Marc on the terrace at Kandinsky and Münter's apartment on Ainmillerstrasse in Munich, photographed by Wassily Kandinsky in 1911

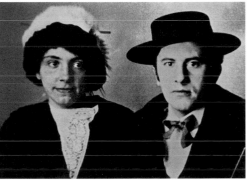

39 Adda and Heinrich Campendonk on their wedding day, 17 June 1913

40 Portrait of Heinrich Campendonk, Sturm postcard, 1916

1918 Campendonk's daughter Gerda is born in May. His artworks are included in the first exhibition of *Das Junge Rheinland* in Cologne. World War I ends on 11 November.

1919 Campendonk joins the Novembergruppe and the Arbeitsrat für Kunst, a union of architects, painters, sculptors and art writers based in Berlin from 1918 to 1921. During the Bavarian Revolution, he and Paul Klee are actively involved in the Action Committee of the Revolutionary Artists of Munich. The mining town of Penzberg, close to Seeshaupt, piques his artistic interest with its strong labour movement. Campendonk makes the acquaintance of the Belgian poet Paul van Ostaijen, and the two men remain close friends until the poet dies in 1928.

1920 Campendonk parts ways with Sturm gallery owner Herwath Walden and begins to collaborate with Galerie Zingler. Solo exhibitions follow at the Galerie Flechtheim in Düsseldorf and Galerie Emil Richter in Dresden. The artist makes the acquaintance of Katherine Dreier, the founder of the Société Anonyme in New York, a society which supports artists abroad.

1921 In the summer, Campendonk is appointed to the Folkwang University of the Arts in Essen. He proceeds to teach at the university for just a few months, afraid of neglecting his own work.

1922 At the end of the year, Campendonk and his family move back to Krefeld. The move is facilitated by art collector Paul Multhaupt, who provides him with a house with its own dedicated studio. Campendonk gets back in touch with his artist friends Helmuth Macke and Heinrich Nauen.

1923 Campendonk is appointed to the Société Anonyme's board of directors along with Marcel Duchamp. He designs stage sets, porcelain, textiles and stained-glass windows.

1924 The first comprehensive retrospective exhibition of sixty artworks is held at the Kunstverein Düsseldorf. Campendonk turns down the offer of a chair at the Cologne Academy of Fine and Applied Arts.

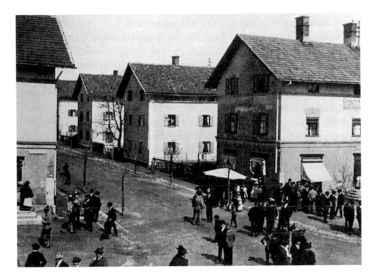

41 Penzberg, c. 1919

42 Adda and Heinrich Campendonk
with their children Gerda and Herbert
outside their home in Krefeld, c. 1926

1925 Campendonk's first US solo exhibition, with 34 paintings, is held at the Daniel Gallery in New York.

1926 Campendonk attends the meeting of the Deutscher Werkbund in Krefeld. He succeeds Thorn Prikker at the Kunstakademie in Düsseldorf in October and receives a professorship for mural and stained-glass painting, mosaics and tapestry weaving. He is commissioned to design his first large-format stained-glass window, at the Marienthal Abbey in Wesel.

1929 He receives a commission to design a mural in the government building in Schneidemühl (now Piła, Poland), issued by Edwin Redslob, the art commissioner for the Reich. Campendonk meets the artist Edith van Leckwyck at an exhibition in Antwerp, Belgium. He travels to Brittany with her on several occasions over the next three years.

1931 Solo exhibition at the Museum of Modern Art in New York.

1932 Divorce from Adelheid Campendonk-Deichmann.

1933/34 Campendonk learns of his enforced sabbatical at the hands of the Nazi administration in May 1933, while on a trip to Norway with Edith van Leckwyck. The artist does not return to Germany, and he and Van Leckwyck go into exile in Antwerp. Many of his works are left behind in Germany. He is dismissed from his teaching post in 1934.

1935 Following a dispute and a campaign against him in the Dutch press, Campendonk accepts a chair at the National Academy of Fine Arts in Amsterdam. He marries Edith van Leckwyck in March.

1937 Six of Campendonk's artworks are included in the *Degenerate Art* exhibition in Munich. At the same time, Campendonk's *Instruments of the Passion* is displayed in the Dutch Pavilion at the World Exhibition in Paris. The stained-glass window earns him the Grand Prix award.

1938 Campendonk turns down an opportunity to be included in *Modern German Art*, a protest exhibition in London showcasing works by defamed artists.

43 Heinrich Campendonk and
Edith van Leckwyck, c. 1932

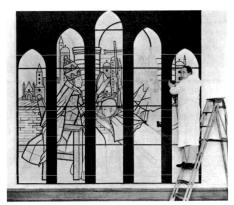

44 Heinrich Campendonk in front of
the cartoon for a glass window painting
in St. Willibrord in Echternach, c. 1930

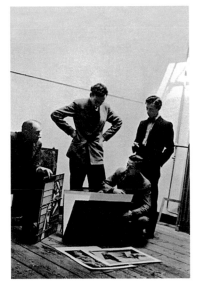

45 With students in Amsterdam, 1947

1939/40 Outbreak of World War II in September. Campendonk is arrested by the Gestapo in May 1940 following the invasion of the Netherlands by German troops. He is soon released due to a lack of incriminating evidence.

1942 Campendonk is called up for night watch duty with the Deutsche Schutztruppe; however, he still manages to continue his teaching activities.

1944 When Campendonk is taken ill, he flees back to Amsterdam while on his way to a German military hospital and goes into hiding with his wife at his student Anton Rover's house until the war is over.

FROM 1946 In a fruitful period of creative output after the war, Campendonk increasingly turns his attention to painting. He produces numerous watercolours, reverse paintings on glass and oil paintings during this period, but ceases to exhibit his work from this point on. Exhibitions featuring works from public collections are held without his support or endorsement; many projects fail as a result.

1950 There are concerted efforts in Krefeld and Düsseldorf to bring Campendonk back to Germany. Long negotiations with the Düsseldorf Academy regarding the directorship of the Kronenburg state academy ultimately fail. Campendonk stays on in Amsterdam.

1951 Campendonk is commissioned to redesign the northern window of Cologne Cathedral. In 1955, however, he is forced to pass this commission on to his former pupil Wilhelm Teuwen due to ill health. He is granted Dutch citizenship.

1955/56 The director of Krefeld Museum, Paul Wember, includes Campendonk's 1925 work *Pierrot with Sunflower* in the *documenta I* exhibition in Kassel without the artist's consent. Campendonk's health deteriorates. He receives an honour from the Dutch government and the city of Amsterdam.

1957 Heinrich Campendonk dies in Amsterdam on 9 May.

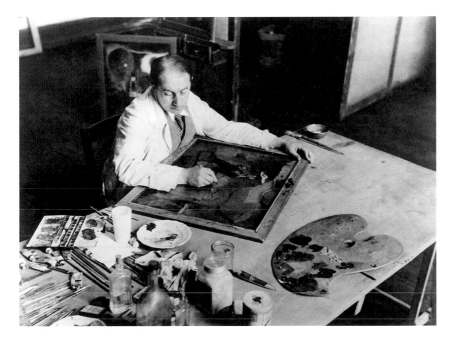

46 In his Düsseldorf studio, c. 1932

47 Heinrich Campendonk, 1947

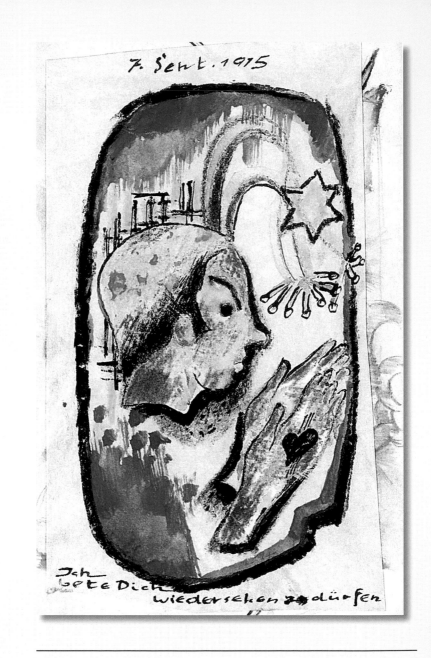

I pray to see you again, 1915
Watercolour on postcard, private collection

ARCHIVE

Finds, letters, documents
1907–1954

I

Between 1905 and 1908, Heinrich Campendonk attended the local school of art and crafts, the Krefelder Handwerker- und Kunstgewerbeschule, which had opened a year before he joined and had earned itself a reputation as a progressive institution. It was receptive to modern ideas of art and welcomed new teaching methods. Besides fostering a solid grounding in artistic techniques, the focus was on fostering students' own design skills – a change from the traditional practice of copying the masters. This new direction was also reflected in the choice of teachers, among them the Dutch painter Jan Thorn Prikker. Despite his eccentric ways, which repeatedly ran him into trouble with the school management, he had a major influence on Krefeld's art circles. Thorn Prikker was adored by his students and left a lasting impression on Campendonk, who studied "Nature studies and lithography" with him. The teacher and his student remained friends even after Campendonk left the school, as the following note from 5 June 1910 shows:

But [learning from] Thorn Prikker brought me the greatest pleasure. He received a wonderful commission in Neuss, for Peter Behrens's 'Gesellenhaus'. Most importantly, however, Prikker has shown great courage again. In July he will be moving to Hagen, where I intend to visit him soon. That man's mind, and his ability to explain everything using incredibly simple everyday words, is so fantastic that one is completely convinced by him and continues to have the utmost confidence in him.

2

Adda Deichmann was an important confidante and muse for Heinrich Campendonk, as shown by the letters they exchanged between 1906, during the early days of their friendship, and 1912, when Adda moved to Sindelsdorf. The following extracts from letters dated April and May 1911 make it clear that Adda was Heinrich's sole source of stability in his most desperate moments.

There is not a soul here [...] not a single suggestion, contact or person in whom I might trust, and there are days when I do not say a word – and yet one must continue to work and soldier on. I am in the process of painting your portrait, just for me, for my heart. There is no joy in the colour, not

ZEUGNIS der Handwerker- und
Kunstgewerbeschule zu CREFELD

für den Vollschüler ~~Halbschüler~~

Heinrich Campendonk, Maler

Eintritt in die Anstalt: 4. **April** 190 5

Sommer -Halbjahr 190 7

Betragen: ~~~~

Unterrichtsfach	Lehrer	Fleiss	Fortschr.	Leist.
Fachzeichnen				
Fachzeichnen				
Werkstatt-Unterricht				
Werkstatt-Unterricht				
Modellieren				
Modellieren				
Entwerfen	Nielsen	1	1	2
Entwerfen	Nielsen	1	2	2
Malen				
Malen		1	1	1
Zeichnen	Jahn	1	1	1
Zeichnen	Nielsen	1	1	2

Zensuren: Entschuldigte Versäumnisse: 13 Halbtage
1 = hervorragend Unentschuldigte Versäumnisse: Halbtage
2 = gut Verspätungen: Bemerkungen:
3 = genügend
4 = mangelhaft
5 = ungenügend

Crefeld, den 10. **August** 190 7 Der Direktor:

the slightest glance clouds the intention, and I will not be able to show it
to anyone without being taken for a madman. But it will be good when I
am well again […]

The artist is an unhappy man; today, he sets himself a goal that he achieves
in six weeks, and already a new one has come along. He must forego every-
thing that other people have, and he is old and sick by the age of thirty: he
knows not a happy minute.

I have become unbearable to others at home and I can no longer afford my
studio; above all, I have no money for materials. The time has come for me
to find a way out at any cost. Either I will have to give up painting for a
while and seek employment of some kind on an estate, or [I must] find the
money to travel to Paris or Berlin and surrender to my fate.

I Campendonk's certificate from the Kunstgewerbeschule zu Crefeld, 1907

3

'There are still obstacles, as you can imagine – the daughter of an officer and a poor painter!' Campendonk admitted to his friend, the writer Walter Schürmeyer, in a letter dated 8 December 1912. He was referring to the prospects for his relationship with Adda, of course. The couple were wed just half a year later, on 17 June 1913 – the same day as two other couples they knew: Jean Bloé Niestlé and Marguerite Legros, and Franz Marc and Maria Franck. In a letter from 12 May 1913, Maria describes the situation in Sindelsdorf to her friend Elisabeth Macke:

Things are really happening in Sindelsdorf at the moment. We three couples, all friends, have all appeared on the noticeboard at the same time – for the marriage banns [...] We have now received a dispensation to formalise our marriage in German law. Of course, we would prefer to keep this as quiet as possible. We are also completely avoiding Sindelsdorf. But you can imagine the jokes about these simultaneous weddings. Still, it is marvellous that we are doing it all again with the others. Campendonk is getting his new home ready – having the walls painted, painting his own friezes, etcetera. Early June is when it will all begin [...] They have a lovely home, four rooms – kitchen, etcetera – in a cottage two kilometres away from the village – *very* pretty. Adda is busy collecting her trousseau; the furniture will be arriving soon. [...] We are getting curious now: how will this all affect Adda? Campendonk is very different now, too – older and manlier.

4

Even today, many people ask whether Campendonk was perhaps too closely aligned with Marc and Kandinsky. Two individuals who were well-acquainted with Campendonk's œuvre – gallerist Alfred Flechtheim and painter Heinrich Nauen – reacted this way in 1911. In a letter to Franz Marc at the end of November 1911, Flechtheim writes:

[...] that these three works are too heavily influenced by the air that flows from you and Kandinsky, and Campendonk has lost a great deal of his originality as a result [...] Would you not agree that it would be more appropriate for Campendonk to work alone again?

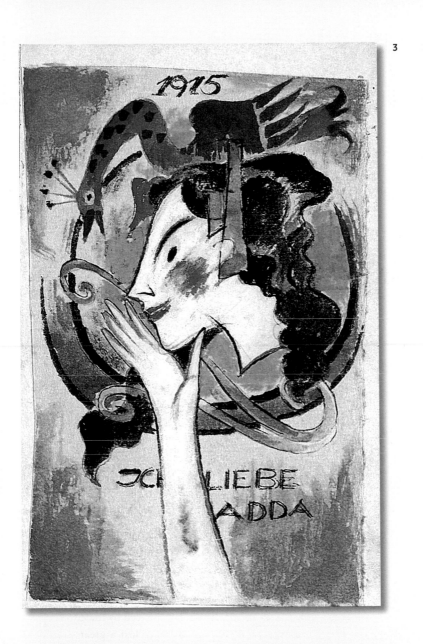

3 *I Love Adda*, 1915, gouache over pen and ink on paper; postcard, private collection

Campendonk himself was aware that this was a sensitive aspect of his development as an artist, and he repeatedly reflected on the matter. Despite his self-confident attitude, he clearly saw himself as an apprentice, something he stressed in a letter to his friend Walter Schürmeyer on 7 February 1912.

I learn a great deal from him [Kandinsky], yet I do not believe I am an imitator. Cleverness or refinement – I choose the elements that are most appropriate for me. My work is progressing well; it has changed a great deal, at least outwardly it is very different, but I am always thinking about everything I did before and its minute qualities, and so I will only rate my most recent painting highly and be able to call it progress if it brings together all the virtues of everything that came before it. It has been a while since I stopped painting nature, at least directly, and I think this is the only way to achieve great harmony.

4

4 Excerpt from a letter from Heinrich Campendonk to
Walter Schürmeyer, 7 February 1912, Kunstmuseum Krefeld

5

5

A number of preliminary studies from the Krefeld years fed into Campendonk's first woodcut, Dancing Farmer, *in 1912. It was the culmination of all the hours spent painting in fields like the great Van Gogh, his initial difficulty getting the proportions of limbs right, and his father's accusation that he was a dreamer. The illustration he sent to Herwarth Walden for the avant-garde* Sturm *magazine was the masterful figure of a farmer wearing a traditional hat and dancing the Schuhplattler, with gestures evocative of German Expressionist dance. In that same year, Campendonk produced two other woodcuts,* Semi-Nude with Cat *and* Half Figure with Tiger, *which are stylistically related to the* Dancing Farmer. *Although these woodcuts were published in the* Sturm, *Marc did not rate them as artworks. Presumably they were too disjointed, too rough and too aggressive for him. Could this rejection from Marc have been the reason why Campendonk failed to show any further woodcuts until after his friend had died? The artist himself calculated that he produced around ninety woodcuts in total.*

5 *Dancing Farmer,* 1912, woodcut, location unknown

6

In his two years of exile in Belgium, Campendonk lived a quiet life in the countryside. He spent his days in Antwerp or Ostende, where the Van Leckwyck family owned a country house. He produced many pencil drawings in this period, most of them depicting rural landscapes or harbour scenes. His style of drawing had changed dramatically, so much so that it was now completely lacking in expressive elements. These almost naturalistic illustrations of rustic motifs only gradually underwent stylisation again. He used an unusual stippling technique for the composition. These pictures show how bitterly the loss of his homeland affected him, especially the experience of being excluded from the artist community and losing the recognition he had fought for so long to achieve. Both in his living environment and in an artistic sense, he reacted by withdrawing into his own shell.

Paul Wember, Director of the Kaiser Wilhelm Museum in Krefeld, maintained a correspondence with the artist between 1949 and 1956. He believed that the bureaucratic hurdles to the official recognition of his years in service were what persuaded Campendonk to stay in the Netherlands, because of the negative impact on his pension entitlements. Campendonk himself spoke of a different motivation in a letter to his friend Walter Kaesbach on 2 October 1952:

As much as I love Germany, I will probably end my days in Holland. The mentality in Germany has altered so much, and I have no desire to live in the country permanently.

Exactly two years later, however, he wrote to Walter Kaesbach saying that because of his pulmonary disease, he would rather "[...] leave wet Amsterdam with its horribly dirty air. [...] Had I not become a [naturalized] Dutch citizen, I would try to find a place to live in Germany."

6 *Sailboat on the Quay*, c. 1934, pencil and gouache on grey paper
Private collection

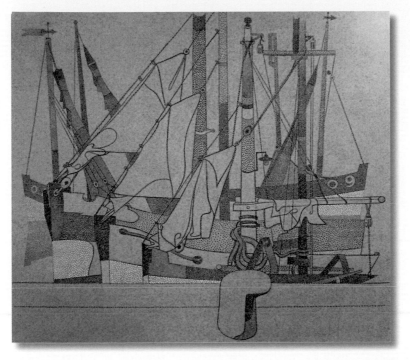

6

SOURCES

PICTURE CREDITS

The originals were graciously provided by the museums and collections named in the captions or by the following archives (numbers are page numbers):

akg-images: 34, 50, 61 0.
bpk/Kupferstichkabinett,
SMB/Jörg P. Anders: 31
Clemens Sels Museum, Neuss: 15, 38, 48
Franz Marc Museum, Kochel am See: 30
Gemeentemuseum, Den Haag: 20, 27, 45
Kaiser Wilhelm Museum, Krefeld: 49
Kunstmuseen Krefeld: 74
Kunstsammlungen Chemnitz: 41
Landesmuseum für Kunst und Kulturgeschichte,
 Münster: 21
Museum Penzberg – Sammlung Campendonk:
 16, 28/29, 35, 51, 55
Städtische Galerie im Lenbachhaus und
 Kunstbau München, Munich: 42/43
Weißenhorner Heimatmuseum: 33
Wilhelm-Hack-Museum, Ludwigshafen: 27

LITERATURE USED

Herbert Campendonk, *Heinrich Campendonk. Das Kokoschka Erlebnis und die Folgen*, Bonn 2002: 70
Heinrich Campendonk. Rausch und Reduktion, Penzberg 2007 and 2012: 70/71, 76
August Macke – Franz Marc, Briefwechsel, ed. Wolfgang Macke, Cologne 1964: 72

Support for the publication has been provided by:
Freundeskreis Heinrich Campendonk
Hubertus Altgelt Stiftung
Reiner Bornefeld
Ketterer Kunst GmbH & Co. KG
Kulturgemeinschaft Penzberg
Kunstzeche Penzberg
Ingeborg und Dr. Thomas Lensch Stiftung
City of Penzberg

Published by
Hirmer Verlag GmbH
Bayerstraße 57–59
80335 Munich
Germany

Cover: *Girl with Cows* (detail), c. 1919,
watercolour and gouache on paper, private
collection
Double page 2/3: *The Cow Shed I* (detail), 1920,
oil on canvas, Kunstsammlungen Chemnitz
Double page 4/5: *Man and Mask* (detail), 1922,
oil on canvas, Kunstmuseum Bonn

For the works of Heinrich Campendonk:
© VG Bild-Kunst, Bonn 2022

© 2022 Hirmer Verlag GmbH, the author

www.hirmerpublishers.com

—
TRANSLATION
Isabel Adey, Edinburgh

—
COPY-EDITING
Jane Michael, Munich

—
PROJECT MANAGEMENT
Rainer Arnold

—
GRAPHIC DESIGN AND PRODUCTION
Marion Blomeyer, Rainald Schwarz, Munich

—
PRE-PRESS AND REPRO
Reproline mediateam GmbH, Munich

—
PRINTING AND BINDING
Passavia Druckservice GmbH & Co. KG, Passau

Bibliographic information published by the
Deutsche Nationalbiliothek. The Deutsche
Nationalbibliothek lists this publication in the
Deutsche Nationalbibliografie; detailed
bibliographic data is available on the Internet
at http://dnb.d-nb.de.

ISBN 978-3-7774-4084-2

Printed in Germany

THE GREAT MASTERS OF ART SERIES

ALREADY PUBLISHED

HEINRICH CAMPENDONK
978-3-7774-4084-2

WILLEM DE KOONING
978-3-7774-3073-7

LYONEL FEININGER
978-3-7774-2974-8

CONRAD FELIXMÜLLER
978-3-7774-3824-5

PAUL GAUGUIN
978-3-7774-2854-3

RICHARD GERSTL
978-3-7774-2622-8

JOHANNES ITTEN
978-3-7774-3172-7

VASILY KANDINSKY
978-3-7774-2759-1

ERNST LUDWIG KIRCHNER
978-3-7774-2958-8

GUSTAV KLIMT
978-3-7774-3979-2

HENRI MATISSE
978-3-7774-2848-2

PAULA MODERSOHN-BECKER
978-3-7774-3489-6

LÁSZLÓ MOHOLY-NAGY
978-3-7774-3403-2

KOLOMAN MOSER
978-3-7774-3072-0

ALFONS MUCHA
978-3-7774-3488-9

EMIL NOLDE
978-3-7774-2774-4

AGNES PELTON
978-3-7774-3929-7

PABLO PICASSO
978-3-7774-2757-7

HANS PURRMANN
978-3-7774-3679-1

EGON SCHIELE
978-3-7774-2852-9

FLORINE STETTHEIMER
978-3-7774-3632-6

VINCENT VAN GOGH
978-3-7774-2758-4

MARIANNE VON WEREFKIN
978-3-7774-3306-6

www.hirmerpublishers.com